EYE TRAINING

A BEGINNERS DRAWING WORKBOOK
"Teaching a way of Life"

By: Professor; Artist; Art Coach
Doug Eckheart
www.eckheart.com

Order this book online at www.trafford.com
or email orders@trafford.com

Most Trafford titles are also available at major online book retailers.

Printed in the United States of America.

ISBN: 978-1-4907-4654-8 (sc)
ISBN: 978-1-4907-4655-5 (e)

Library of Congress Control Number: 2014916346

Trafford rev. 09/17/2014

North America & international
toll-free: 1 888 232 4444 (USA & Canada)
fax: 812 355 4082

BEGINNING DRAWING WORKSHOP
OR
EYE TRAINING 101

INTRODUCTION: The Author/Artists Personal Philosophy

To Draw= Eye Training= New Awareness=Change Therapy=NEW PERSON

Drawing from observation is a life changing experience. You are training your eyes to see "into" the world around you and not just "look at" this same world. Similar to training your ear to "hear into" music, or ear training, you learn to differentiate between whole and half notes and simple compositions such as "Mary Had A Little Lamb." You do not begin ear training with Mozart on the piano. Quarter note, eighth note, sixteenth note, sixty-fourth note, come later, with much instruction in basics and much, much practice. It is the same in visual art. Indeed, formal training in all of our inborn, natural senses; the eye, the ear, taste, smell, touch, movement will take much time, practice, instruction, more practice and in some of our situations a kind of relearning or rededication of these basic sensory systems.

Think about the amount of hours, days, weeks, years it took you to learn any skill in sports, music, writing, etc. (you fill in the blanks) just the very simple task of sitting down in our contemporary world of mega seconds, megabytes, and observing forms in space for more than one minute is truly a revolutionary idea. Training your eye and your hand to coordinate is an activity of careful, patient, selective observation and hard work. This "eye training" will require repetition, do over, practice, and do over. It will demand <u>all you have</u> and more. It is an activity that is totally opposite our contemporary lifestyle of fast food, fast talk, fast touch, fast marriages, and fast technologies, fast, fast, and faster.

It is my lifelong philosophy that "eye training" will create a new awareness of everything and everyone within that world. This new awareness will create a new you, a more loving, and creative personality, an individual who will become a better, more attentive friend, husband/wife, father/mother, brother/sister, etc. An individual who taps into training the eye becomes more observant, more understanding, more compassionate, and you really "see into" everything around you.
So to begin the new you, we must first test your current abilities to see and assess what you see.

Follow these instructions:

1. Look at your immediate surroundings, if it's your residence, look within a particular room.

2. Pick out a familiar object within the room, something you can hold in your hand, something simple (i.e. small vase or container.)

3. Set the object in front of you a few feet away. DO NOT DRAW AT THIS POINT! Just study the object. <u>Time this activity to 5 minutes!!</u>

4. **<u>Read this below before you begin!!</u>**

 Ideas to think about during your 5 minute activity.

 *What is the proportion and scale of the form?

 *How large or small is it in relation to other objects in the room?

 *Does the object have curves? Are they evenly divided or symmetrical?

 * Or are they uneven, asymmetrical?

 - Is the bottom larger than the top?
 - Is the object larger or smaller than say, your hand?

 If so, how much larger or smaller.

 - Is the object reflective, shiny, dull, glass (see through)

 Ask yourself these questions, be a proactive and engaged learner.

 Begin to create a dialogue with your inner voice, listen to it, begin to trust your

 eyes, yourself, <u>a very important First Lesson</u>, critical to "eye training."

Be proactive, be engaged, create inner voice dialogue, listen, trust, are all very important concepts that I will continually reference during this workshop in "eye training" OOPS,

I mean drawing.

COACH ECKHEART PHILOSPHY
(Think about this idea)

Your surroundings: colors, textures, shapes, light, people, habits, objects, (et.al) will create patterns and contrast all around you. They are your choices, you become them:
at one-
They become you.

"Surround yourself with what you love, for you will become at one with them.

CHAPTER 1

Lesson 1: NO PEEK

Follow these instructions:
<u>(Read before drawing)</u>

1. Take the same object you were observing during the 5 minute exercise in the introduction. Please set this object on a table a few feet from you.

2. Use a 2B or HB pencil and paper in this booklet on <u>practice pages, 4 to 8.</u> Turn to page 4 to begin this exercise.

3. Now, <u>look only at the object on the table</u>, once again, remember your observations from the 5 minute exercise.

4. Looking only at the object. On the paper, place your pencil in the middle of page 4 **WITHOUT LOOKING AT THE PAPER**; begin a line (no shading/outline only) drawing of the edges or contours of this form.
 <u>I REPEAT: Do not look at the paper</u>, sense what your hand is doing and coordinate your eye and hand, think peripherally, sense what your hand is doing, put your eye and hand movements together.

5. Go slow, no hurry. Do not take your pencil off the paper, one continuous line following the contours of the form. The very point of your pencil and your eye are at one. Coordinate the two (eye to hand).

6. <u>Do not worry about how the drawing of the object looks at this point.</u> We are only interested in how you're concentrating on getting your hand to follow your eye, put the two as one. The more you concentrate, the harder you try, the more your drawing will look strange.

7. You can change objects if you want during this exercise. An old shoe or hat will work.

8. Then repeat this exercise in all four boxes on page 5. Take your time. Go slow! Concentrate; *avoid peeking at your drawing.*

9. Then go back and read this again (one through nine) and practice at least another Thirty minutes. Use the front and back of pages 5 to 8.

ECKHEART PHILOSPHY

Remember, the no peek exercise is all about hand-eye coordination and training them to work together. Also, earlier in this workbook we mentioned, relearning, and practice; do again, careful, selective, and slow down.

Example, much the same as training your hands & eye to work together when playing music, (ie.piano) read the music, sense your hand on the keys or dribbling a basketball and not looking down at the ball. Look up and read the music, sense the hand, coordinate hand to eye. Think peripherally, a sensory response.

Practice no peek at least 30 minutes per day for the next 5 to 7 days. Use the pages (front and back) on <u>pages 4 to 8</u> in this booklet and any other paper (as needed) in a wire bound practice sketchbook.

<u>PRACTICE "No Peek" exercise below</u>

Chapter 1 "NO PEEK EXERCISE"

The drawing should not look like the object this is not about an accurate drawing of the object-
<u>**It's about coordination! Hand to eye!**</u>

Baseball Hat

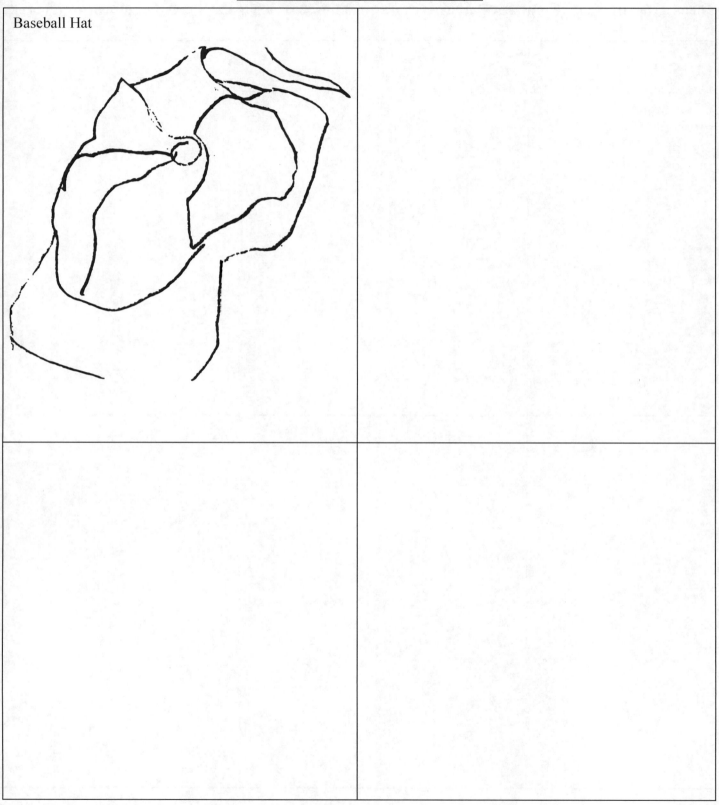

<u>GO SLOW!</u> <u>DO NOT HURRY!</u> NOTICE EVERY SUBTLE CHANGE IN THE EDGES OR OUTLINE OF THE OBJECT YOU ARE DRAWING!

Chapter 1 "NO PEEK EXERCISE"

Concentrate on not looking at the paper, but coordinate your hand to follow your eye without looking at the paper. THIS IS DIFFICULT!!!! Think peripherally-sense your hand- Don't look-practice every time before you draw for 10 minutes. Purchase a wire bound 9x12 sketch book to practice, practice, practice!!

Chapter 1 "NO PEEK EXERCISE"

Practice no peek exercise at least 30 minutes per day for the next 5 to 7 days.
Find a quiet place, uninterrupted, high concentration level.
If you need more practice pages, use the wire bound sketchbook.

CHAPTER 2

LESSON 2: "TAKE A PEEK"

We will now move on to an exercise called "Take a Peek". This involves <u>moving your eye rapidly</u> (rapid eye movement) or R.E.M., back and forth from object (what you are drawing), back and forth quickly from object to your paper. But REMEMBER, DO NOT STOP DRAWING when you take your eye back and forth. Again coordinate eye and hand. Count 2 or 3 seconds, and back to object, (eye movement) back and forth quickly, while you continue to sketch *light* lines of the objects contour.

Follow these instructions:
Read before drawing.

1. Now gather a group of small objects (perhaps 3 objects) i.e. a group of varied shapes from bathroom or cleaning supplies. These objects should <u>not be complicated</u>!!

2. Put them together in a simple arrangement on a table. Similar to the illustration on page 11. Take a look! What looks good together? Size? Scale? A good fit!

3. Study them with the same inquiry and proactive "inner voice" dialogue from the introduction and Chapter 1 lessons. But now you have a "group", a "family" if you will, not just an "individual" form to study and examine visually.

4. Go to a clean piece of paper in our workbook on page 12. Begin your study of sketching of these forms with very light outlines of the entire group. No details. See page 11 for author's illustration of this exercise.

5. Remember, you are allowed to "take a peek"/R.E.M. Quickly moving your eye back and forth from the object to paper, and back 2 or 3 seconds and back 2 to 3 seconds and back. BUT continue to sketch DO NOT STOP & START. Put your hand & tip of pencil together in coordination with where your eye is moving over the outline of the forms. Complete all the objects! Use light lines! Hold the pencil in hand lightly and loose about 2/3 of way down from the top. Get used to handling your tool by balancing your hand with your smallest finger balancing on the paper.

6. Once finished with all the objects, it is time to assess or critique your work. Step back and set your workbook upright so you can look quickly from your sketch to the objects. The work sketch book page or drawing should only be one foot or two apart to from the actual objects to accommodate this critique. Be HONEST with yourself. Remember TRUST instincts.

7. If you wish to make only very subtle changes & shifts, draw darker lines over lighter lines. If you need to make bigger changes in scale, spaces between, etc. you may need to erase or start again. You decide.

8. Remember, this is a visual (calisthenics) like sports, a warm up exercise to develop hand-eye coordination. Again Chapter 1, "NO PEEK" and Chapter 2, "Take a Peek", need practice, practice, practice, so try rearranging these objects or others in a new group & use practice pages on 11 - 15.

9. Practice these visual (calisthenics) exercises, "No Peek & Take A Peek" 30 minutes each for the next 5 to 7 days. <u>DO NOT</u> move to Chapter 3 until you do this faithfully.

Reminder: Get a practice sketch book wire bound 9"x12" or 11"x14" and practice. Chapter 1 & Chapter 2 every time before you draw anything for the next two to three months.

COACH ECKHEART PHILOSOPHY
IDEAS TO THINK ABOUT
YOUR ART COACH SEZ:

**Do not be too critical of your work at this point. DO NOT QUIT, TRY AGAIN!
PRACTICE! PRACTICE! PRACTICE!**

ART COACH, ECKHEART SEZ:
Hit thousands of golf balls to become a good golfer.
Work on the practice range!
Train your eyes, coordinate hand & eye. Create thousands of practice lines.
Rearrange objects, use new objects, and do again. REPEAT, take a peek, draw light lines, trust yourself, a new awareness, change therapy, A NEW YOU.

CHAPTER 2
"Take a Peek Exercise"
3-5 Objects
Practice page 1

Take a very quick peek, just moving your eye quickly back & forth from the object edges you are studying and back to the paper. Count to two, and back—two and back—very rapid eye movement from paper & back to object. Keep sketching put your eye and hand together as one. Just like playing piano-read the music-sense the hand!

COACHES ILLUSTRATIONS:

draw 1

object smaller not as wide

closer

draw 2

(Sketch again- make corrections)

CHAPTER 2
"Take a Peek Exercise"
3-5 Objects
Practice page 2

Arrange your own objects & practice the same concepts as on page 12 (two second peeks and back-2 second peeks and back)

CHAPTER 2
"Take a Peek Exercise"
3-5 Objects
Practice page 3
Remember: Light to Dark lines-loose light lines-hold the pencil lightly in your fingers-work on hand eye coordination-practice more no peek and peek exercises in your wire bound sketch book.

CHAPTER 2
"Take a Peek Exercise"
3-5 Objects
Practice page 4
Draw on front & back of page

CHAPTER 2
"Take a Peek Exercise"
3-5 Objects
Practice page 5
Draw on front & back of page

CHAPTER 3
PROPORTION AND SCALE

Once you have developed a connection to hand eye coordination through "NO PEEK" and 'TAKE A PEEK". We can now introduce the concept of "proportion and scale."

If you return to lesson #1 on page 2, where you were asked to pick an object in your immediate surrounding and look at it in relation to other objects in the room or on a table. How large or small is it in relationship to other objects nearby? In lesson #2, "TAKE A PEEK", you were asked to form a group of objects (3-5 in number).

Now, in Chapter 3 let us:

1. Take another group of objects and regroup them next to one another.
2. Try to make an interesting and pleasant arrangement.
3. Study the size, scale, and proportion of each object, especially in relation to one another. Ask yourself, which object in the group is the largest? Now use that object as your largest form of the group.
4. Now, take your pencil and hold it arm's length and measure with one eye closed, taking your thumb down the length of the pencil, how high and how wide the object measures.
5. Use this as a guide for proportions and scale relative to the other objects that are in your grouping. Make a line drawing of these objects (see illustration on page 17.)
6. Eventually your eye will begin to intuitively "see into" scale and proportion in your composition.
7. Once your line drawing is finished, (no shading) hold it up next to the group or photo, and compare. Make corrections similar to earlier exercises. Draw darker lines over or erase as necessary.

Measure with your pencil

Use the pencil to measure one object- perhaps the largest object- then use the same measure against the other objects in your group. Is it taller, by how much? Notice the sphere or circular form would it fit into each object twice in height and at least once in width? Pencil measuring will help determine scale from object to object. Eventually, the more you draw, this will become an intuitive process and the less you will rely on the pencil measuring- Be sure to look through with one eye closed when you align and measure forms.

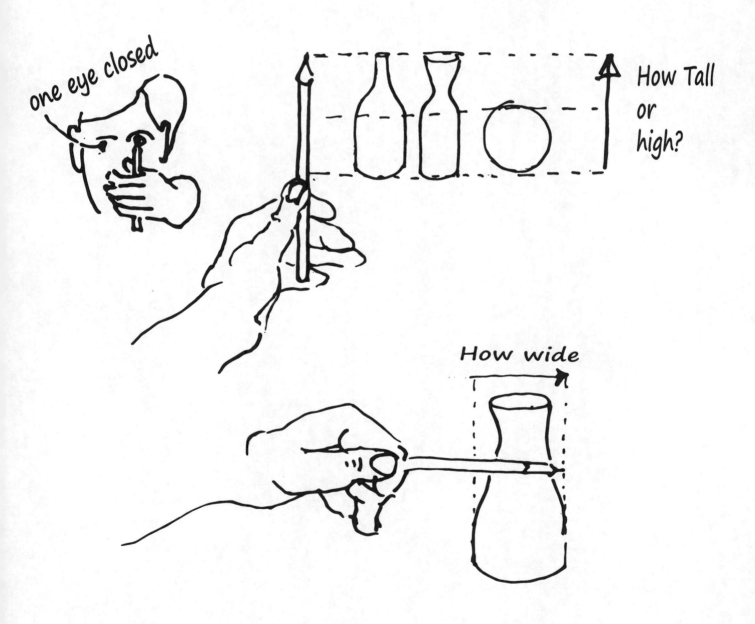

Practice Drawings
Other groups of Forms
Work on scale from one form to another

Practice Drawings
Other groups of Forms
Work on scale from one form to another

Chapter 4
Basic Shapes

When you are learning to draw from observation and "eye training" or basic training boot camp, you need to learn the four basic shapes to look for in the natural world. Then you need to look for these basic shapes in everything you draw and see. These basic shapes and variations of them, will form a foundation like a solid foundation or basement when building a house. Then you can build on this foundation for many years of drawing and eventually painting, printmaking, design, sculpture, **any and all** visual art form-making.

Follow these instructions:

<u>Read before</u> drawing in Chapter #4

1. Basic Shapes- these are the four basic shapes you will need to learn and draw. Especially in Chapter 4 when we begin looking at these forms and shapes in space and at a variety of eye levels.
2. Practice drawing each of these beneath your coach's example.
3. To achieve control of hand and coordinate to create these shapes in space requires some technical control with your tools (i.e. pencil, brush, golf club, basketball, etc.) So, back to the practice field.
4. Let's practice straight lines (horizontal & vertical), curved lines, and angular lines. All of this aimed at technique improvement and our ability to draw circular, cube, or rectangle, cylinder and cone. See practice pages 22 to 29. Use the front and back of each practice page.

CIRCLE

CONE

RECTANGLE

CYLINDER

1. Circle or Curve

(Coach's circle)

(Your drawings)

2. Cone or Diagonal & Circle

(Coach's cone)

(Your drawings)

3. Rectangle

(Coaches rectangle)

(Your Drawings)

4. Cylinder or Circle & Rectangle

(Coaches Cylinder)

(Your Drawings)

Chapter 4
BASIC SHAPES
Straight lines, Curved, Diagonal, Horizontal/Vertical
Coaches Illustration

Vertical Lines (you fill in the rest of the box)

Circles (you fill in the rest of the box)

Horizontal Lines (you fill in the rest of the box)

Diagonal Lines (you fill in the rest of the box)

Horizontal Lines:

Perpendicular to horizontal (right angle) of the page:

THIS

NOT THIS

Fill this page with horizontal lines.

Chapter 4
BASIC SHAPES
Straight Lines, Curved, Diagonal, Horizontal/Vertical
You practice here

Vertical Lines	Circles
Horizontal Lines	**Diagonal Lines**

Chapter 4
BASIC SHAPES
Vertical Lines, Curved, Diagonal Lines

Perpendicular to edge of page: Straight Lines

←This

→ Not this

Fill this page with Straight Lines:

Practice Page
Draw Vertical Lines Parallel to papers edge
All the way across the page!!
Left to Right

Practice Page

Draw <u>horizontal lines</u> parallel to papers edge. All the way across the page left to right. Start at the bottom and work up to top.

Like this & go up (example below) **Not this….(Example)**

Repeat circles across the page left to right as circular & rhythmic as possible.
Then begin varying the size of the circle to the bottom of the page. Fill the page.

Try some ellipses/angle or tip the circles:

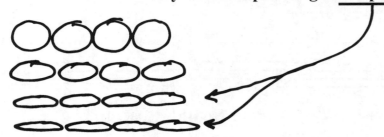

28

Chapter 4
Lesson One- BASIC SHAPES
Practice Page—Vertical, Circle, Diagonal
(Use front and back of this page to practice)
***Remember: This exercise is a <u>means to an end</u>! Not an end in itself!!**

Chapter 5:
EYE LEVEL

Follow these instructions:
Read these before you draw in Chapter 5

1. So far we have learned to practice hand/eye coordination and the four basic foundation shapes to use as a basis for everything we see and draw.

2. We are now moving into the study of <u>one of the most important visual techniques to learn in observation drawing and our eye training:</u> <u>Where is your "eye level"??</u> If you draw an imaginary line with your arm outstretched from left to right at your eye level when you are seated, <u>THAT is your eye level!</u> Note: How the top planes of the rectangles and cubes (or tables and chairs in the room) will change if you stand-up and repeat this same arm outstretched exercise. <u>Notice:</u> How the same planes and objects are now below your eye level. Imagine if you stood on a step ladder these same objects would be far *below* your eye level. Or if you lay on the floor. <u>So remember,</u> everything you see in observation drawing is in relation to this same eye level.

3. Let's practice:

 Using the circle first, begin by tipping the circle slightly so you create an ellipse which will gradually become even more elliptical as you turn the circle more and more until the lines of the circle become one.

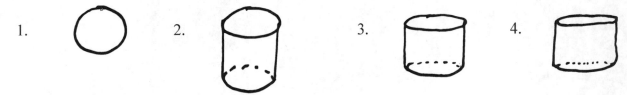

4. Now do the same with the cube or rectangle form this

 To this to this

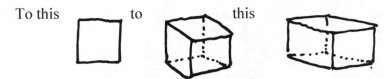

 Notice: The more you tip the top plane of each basic shape you lose the plane of the shape. You also lose the descriptive or character of that plane.

5. Let's try this same exercise with a <u>cylindrical object</u>. (i.e. an open-ended clean can. Remove labels or something like it, small, you can hold in your hand.)

Circular Lines
Repeat circles across the page left to right as circular & rhythmic as possible

Then begin varying the size & tip the angle of the circle at the bottom of the page to fill the page

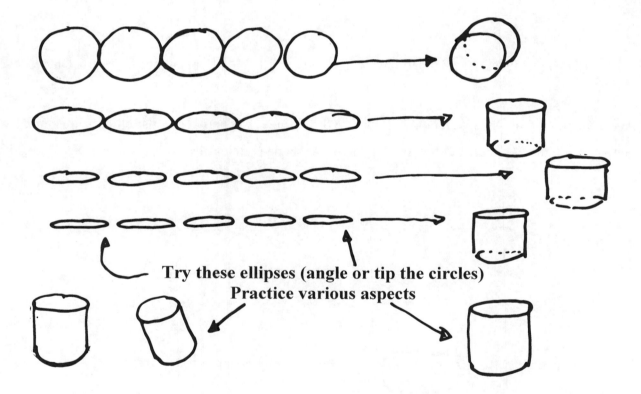

Try these ellipses (angle or tip the circles)
Practice various aspects

Ellipses
Cylinder

Turn the cylinder in your hand, close right eye if right-handed or left eye if left-handed. You need to see at arms-length, several different views or aspects of the circular ellipse on the end of the cylinder.

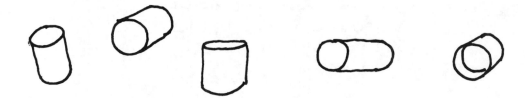

Remember the closer to eye level, the closer the elliptical lines will appear. They will come together like this:

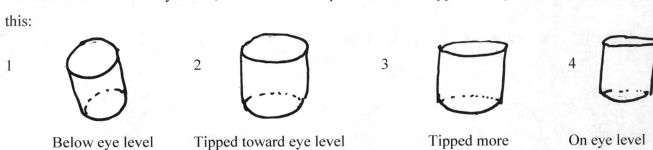

1 Below eye level 2 Tipped toward eye level 3 Tipped more 4 On eye level

Also remember that when you look directly into the cylinder so the two circular ellipses are almost one—turning the cylinder slightly you will have two shaped circles next to one another. <u>See dotted lines</u>

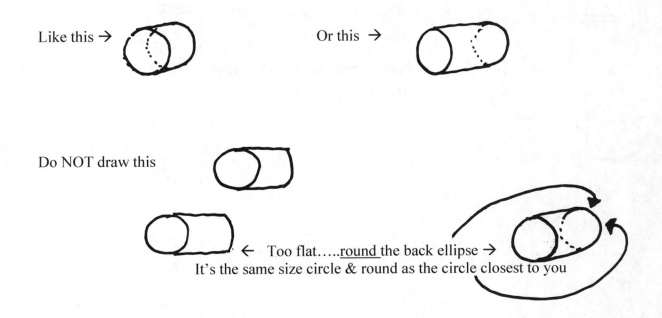

Like this →

Or this →

Do NOT draw this

← Too flat.....<u>round</u> the back ellipse →
It's the same size circle & round as the circle closest to you

Also, a <u>rectangular object.</u> Same size, perhaps a small box. Hold it below eye level- close one eye (right eye if you're right-handed) and sketch <u>lightly</u>. Hold pencil loosely, draw light lines. Same with cylinder

6. Follow instructions on each of the pages numbered 32 to 41. And use the practice pages enclosed in the booklet.

7. Practice, practice, practice. Don't forget to start each studio session with some "no peek and partial peek" warm-up in your wire bound sketchbook. About ten minutes or so of visual calisthenics coordinate hand & eye → especially "Take a Peek."

8. You will need to discipline yourself ---will yourself---take time for yourself---YES, indeed, be selfish. Set aside time, an hour or two, for two or three days, an evening, weekend, whatever works for your schedule but you MUST dedicate and set aside time, disciplined time on a regular basis or you will NOT IMPROVE!!! You will spin your wheels and start over, and over, and have to go back to the beginning. Improvement will come with dedicated time, practice, and a real passion and love for this activity.

How serious are you? How bad do you want this?

"Only YOU hold the key!!!"

- Art Coach Eckheart

Practice Page
Circles & Cylinder

Use a variety of circular & cylindrical objects- turning them at a variety of angles and aspects for practice.

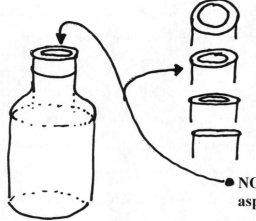

1. Look straight into the bottle for perfect circle

2. As you tip the bottle toward eye level the ellipse gets more shallow

3. Even more tipped & shallow

4. To at eye level

NOTE: Coach Sez: #2 is most descriptive of the form & best aspect to describe the form.

Use this practice page & following pages 34 and 35 (front and back) to practice cylindrical objects in a variety of aspects and views.

Practice Page
Circles & Cylinder

Turn the small box in your hand, (same as the exercise with the cylinder), arms-length, one eye closed, sketch several different aspects or views of the box. *Coach sez:

Notice the dotted lines <u>see</u> through to back of box for parallel lines

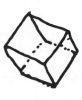 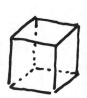 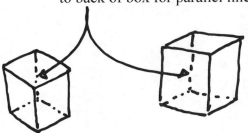

Copy mine here →

Again remember the closer to the eye level as with the cylinder you will see less of the plane till the two lines are right on top of one another.

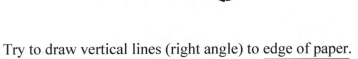

1 2 3 4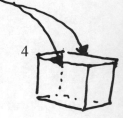

You can place a cylinder with the box- a good way to double check your planes and ellipses.

Also: Get lines on the plane-parallel

This → Parallel Not this

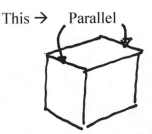 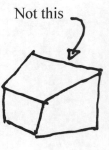

Try to draw vertical lines (right angle) to <u>edge of paper</u>.

This → Not this →

36

Remember: A well-drawn cylinder could become…

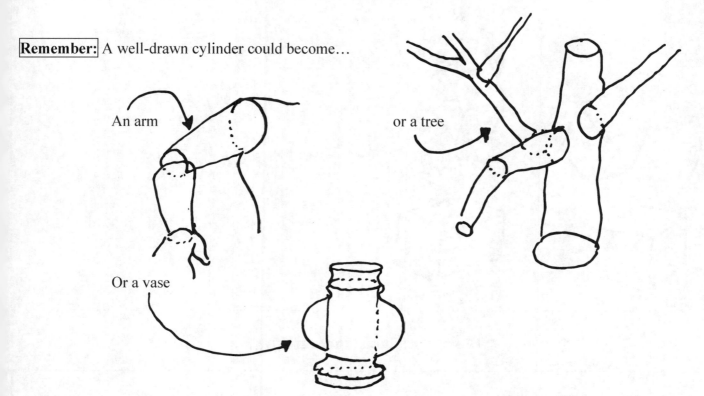

An arm

or a tree

Or a vase

Look around you now-how many objects or forms in the room start with a cylinder?

Write them down!

(Use rest of page to right down things you see)

Eye Level – "Boxes"
Practice Page

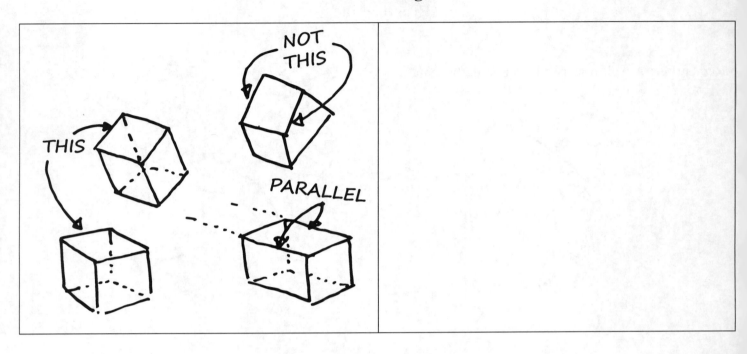

Boxes with construction lines

Practice Page-"Cubes & Rectangles"
Variations on forms/objects that fit into rectangles

Coaches Illustrations

Draw some of your own *!!*

Folding chair

Tables

Changing Eye Level- "Box Rectangle"
Variations

Remember a well-drawn box or rectangle can make many forms in space both outside in the landscape and inside a room or house.

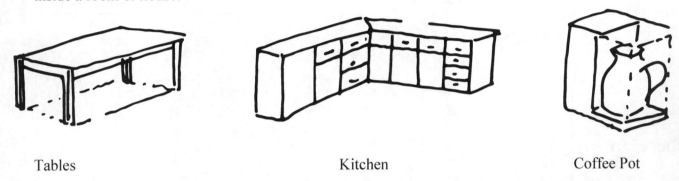

Tables Kitchen Coffee Pot

Look around your room. How many forms or objects do you see? The room itself? Start with a rectangle or rectangular form or variation thereof. Remember if you draw these forms from where you are sitting—check your eye-level---where is your eye-level in relation to the forms or objects in front of you? Then relate the planes in relation to your eye-level.

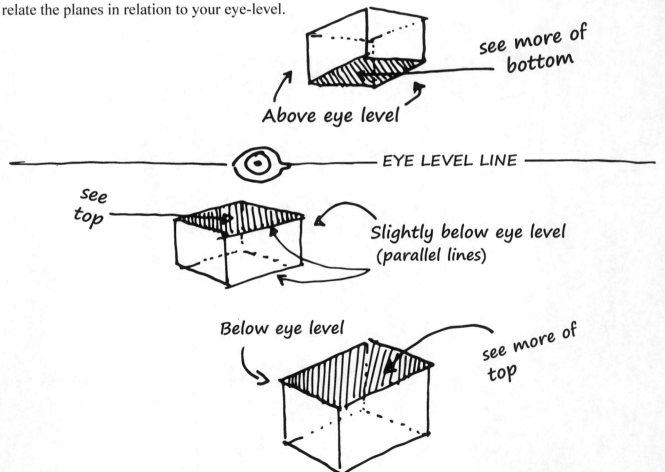

see more of bottom

Above eye level

EYE LEVEL LINE

see top

Slightly below eye level (parallel lines)

Below eye level

see more of top

Changing Eye Level- "Box Rectangle"
Practice Page
(Use front and back)
Same as page 35 but use box instead of cylinder.

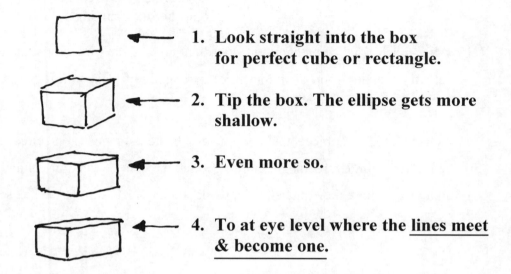

1. Look straight into the box for perfect cube or rectangle.

2. Tip the box. The ellipse gets more shallow.

3. Even more so.

4. To at eye level where the <u>lines meet</u> <u>& become one.</u>

Chapter 6
Eye Level-
Variations on 3 to 5 Objects

Follow these instructions
Read before drawing

1. After much practice on hand-eye coordination, and drawing ellipses and planes at various eye levels, let's try a small group of simple objects to three to five in a group.

2. Select a group of objects that are not complicated, opaque (non-reflective, not transparent) that are as close to a cylinder, rectangle or cube, round or spherical, and/or conical. Arrange the objects on a table in a place where they may sit for a while. Pick objects similar in size, scale and proportion.

3. Try and sketch light lines, of your grouping on eye level. See page 45.

4. Then on another practice page try the same objects above eye level. See page 47.

5. Then on another practice page try the same objects <u>completely below</u> eye level. See page 46.

6. **Practice, practice, practice**---sez Coach Eckheart. Keep the drawings in line---light to dark lines, loose to light. Try to develop the entire drawing. Stand back and look back and forth from your drawing to the objects. Make corrections as you go and need. Use pages 48 to 53 to practice.

Chapter 6
3-5 Objects in Line

A similar exercise as on pages 34, 35, & 37.

Only now we are attempting to create objects at different eye levels. On eye-level, above eye-level, and below eye-level.

* Don't forget practice "No-Peek/Partial-Peek (10 minutes before you draw.)

Then copy my drawing from page 46.

On the page below.

Chapter 6
How 3-5 Forms/Objects Fit into the Structure of form

(Artist's illustration as example)

Rectangle or → **Cylinder**

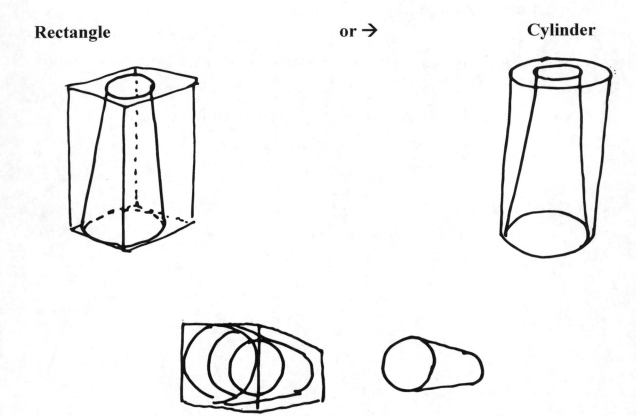

(Artist's drawing as example)

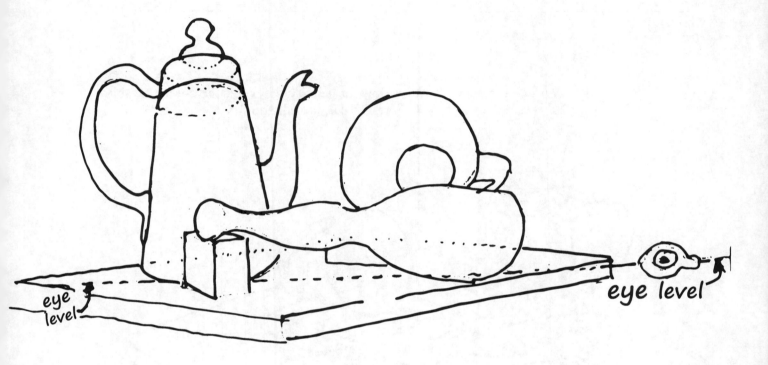

Eye Level

How far <u>below </u>eye level is the corner of table?
Draw table top <u>first</u>

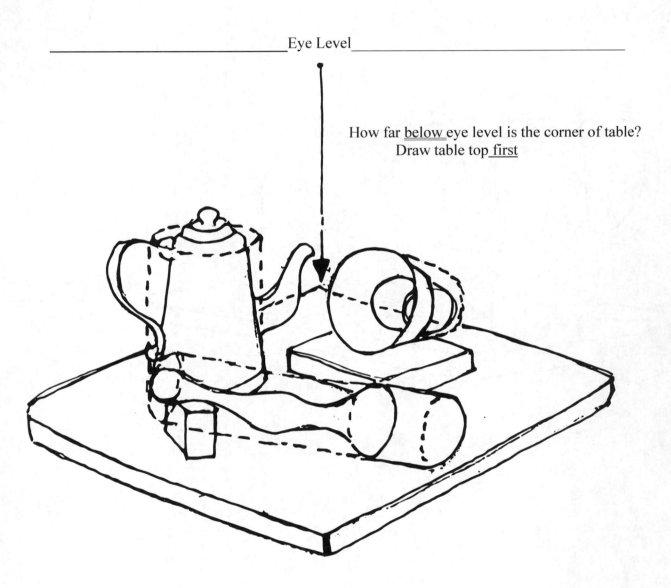

Chapter 6
3-5 Objects
<u>Above</u> Eye-Level

Chapter 6
Practice Page

Chapter 6
Practice Page

Chapter 6
Practice Page

Chapter 6
Practice Page

Choose your own subject matter. Try to pick forms that you can find and discover the same structure beneath—(i.e. cylinder, rectangle, sphere, etc.)

**Don't forget to practice, No-Peek & Partial Peek before you draw—EVERY TIME!!

Hand/Eye Coordination. Work in your sketchbook for more practice, practice, PRACTICE!!!

Chapter 6
Practice Page

SUMMARY:

Now you can begin to see how important "eye level" where you sit or stand or where your eyes are located in relation to subject matter, will impact what you see and observe and eventually how you draw those objects. Also, how to see and draw simple geometric forms; circles, squares, diagonal and related planes in space to transform them into more complex forms. (i.e. an inverted cylinder into a tree limb or arm page 37, or a rectangle into a room interior, a table top, or a barn or house. Start with the basic shape first, then, add windows, doors, and details. Not details first, but rather basic shapes first.

Chapter 7
Shading/Blending:
A World of Light & Dark Contrast

When you are more comfortable with drawing basic shapes, eye level location, objects in space, scale & proportion through practice and line drawings, then it's time to move on to some lessons and learning related to shading, light to dark and creating the third dimension. The exiting interplay of light and dark contrast and patterns of light to dark in space.

This world of light and dark pattern to shapes and shapes to patterns is, for me, as an artist, the most visually exciting and rewarding process in developing a "finished drawing" that may lead to a study for a further exploration in a painting, print or collage.

Follow these instructions:
Please read before drawing

1. Sharpen FIVE soft lead pencils either 2B or HB. Use sharp pencils for this exercise.

2. Use pages 57, 58, 59, & 60 in this booklet as practice sheets.

3. Create an elongated rectangle 1"x8"

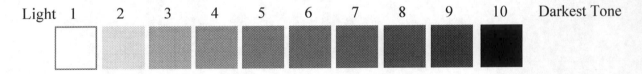

4. Create a value scale- mid-tone is #5. Then create the lightest shade #1 on the left and gradate tones slightly darker to the mid tone #1 to #5. Then to the darker tones #6 to #10. Number 10 is the darkest dark you can make on the page with your soft pencil.

5. Think of this value/gradation scale as similar to the tonal notes in music. #5 is the middle C, and your variations lighter and darker as ½ note, ¼ notes. 1/8, 1/16, 1/32, 1/64 notes on a musical scale.

6. Suggestions when working with shading techniques and value scale:
 - <u>Use sharp pencils:</u> buy a small hand-held pencil with a stainless steel sharpener blade. Rotate 4 or 5 pencils- very sharp in working order at all times. A sharp point will put you

in better touch and feel to the paper, especially at 1/16, 1/32, 1/64 notes…Oops! I mean values.

- Work on gradations of these tonal values with pencil tip ONLY—no finger smudging or blending tools.
- Use only the tip of the pencil and vary the pressure of hand to pencil to achieve these gradations.

7. The amount of pencil pressure, especially between the values of #2 to #4 and #6 to #9, or "connective tones" are the most difficult to achieve, but at the same time most important to your tonal composition. Similar to a musical scale, they are more difficult technically and tougher to master. Remember the whole note, half note, "Mary had a Little Lamb", analogy? We don't start our playing Mozart.

8. Again, practice! Practice!! Practice!!! With diligence, passion, and will power, you CAN achieve! GO FOR IT!

9. **Papers-** A word about paper and surfaces:

 The weight of the paper is measured by the weight of one ream- 500 sheets is one ream. Therefore, if the paper you are using is 60 lb. bond paper—500 sheets weighs 60 lbs. If you are using 200 lb. paper, 500 sheets weighs 200 lbs., making it triple the weight per sheet, so it's heavier and thicker. You can see and feel the type of paper, be sure to feel the paper surface.

 I encourage you to experiment, but typically, I recommend a heavier weight 100 lb., very smooth, coated surface drawing paper-something like what you are practicing on. This is not meant to be an end in itself but rather a means to an end.

 Always remember- you must find and discover through practice and experimentation, what works best for you. Keep in mind there are basically 3 types of paper surfaces-

 1. Cold Press- bumpy but lower relief on the surface.
 2. Rough- very bumpy and pebbled.
 3. Hot Press- smooth surface.

 The heavier the weight, the thicker the surface, and the more soak ability—for wash and watered technique, the heavier the paper, the less soak into the surface. Cold press and rough surface work well with watercolor, wash and line etc. Smooth surface works well with charcoal, pencil, and dry tool techniques.

10. **<u>NOTE:</u>**

If you would like to experiment with a few sheets of heavier paper in your shading exercise, please purchase at your local art supply store a 140lb. hot press smooth paper. It is a very smooth paper which should improve your shading technique.

11. **<u>Coach Sez:</u>**

In all of life it is "human to error and divine to forgive." That's Shakespeare, not Coach Eckheart. You will never learn anything unless you are willing to make mistakes and TRY AGAIN! FORGIVE YOURSELF! Go for it! Try again!! PRACTICE! PRACTICE! PRACTICE! Like losing weight it takes time! Give yourself 6 months!

Heavier Paper

Practice Shading
(Page 3 of 4)
Save pages 59 & 60 for a later sketch

Chapter 8
Composition

Up to this chapter, we've been concentrating on various concepts and exercises and have practiced techniques aimed at improving your ability to see and transform (translate) the world around you to paper.

Now, we have arrived at a more complex point in your eye training, picture composition- how to use objects in space. It will also begin your "personal thumbprint" into exploring the world you see, feel and express in your work. Not only how you each individual object, but how you see them as a group, collaboration, a family of shapes interacting in line, shape, value, and pattern to create the you in your work.

So now we begin to personalize your object selection to draw. Suggestion, select objects that are important to you, but not too complicated on the surface or edges. Also, perhaps a theme; music, cooking, athletics, objects familiar to you and things you use quite frequently. Consider a mix of surface texture variation- glass, metal, cloth, fiber.

1. Arrange and rearrange these objects on a table with careful thought to "how they collaborate" and work together. Think about: spacing between, scale, high to low-eye level (illustration). Try to place this table in a space or area that will not be moved or changed for a few days.

2. Light the objects with a direct light move the light how, high or eye level. Check length of shadows and interaction of shadows as they move and access the forms. Once you finalize the light source and placement of objects, do not move anything!! Keep as is for the length of time you are working on this project.

3. Take a photo for reference of this still life set up. Page 62. Also, seat yourself at the same place each time you view this composition. See pages 63, 64, 65, & 66.

4. Begin sketching (light line-rough sketch thumbnail); in about one hour complete a line drawing. (Very light pencil lines.) See page 63.

5. Hold the drawing up or set it up about four feet away and next to the still life so you can look back and forth quickly, from your finished line drawing to the objects and back-make corrections if necessary. This process should be simple. If you have made your sketch lines, light, loose and flexible.

6. Shading the composition- Turn on the direct light which you set up before you started the composition drawing. Other lighting and window lighting should be dimmed or curtains pulled. This light needs to remain constant and not change in any way for the next few sessions.

7. Study the pattern of light and dark values. Think back to the value scale and related techniques related to shading. Begin your shading process by developing the lightest tone #1 to the mid-tone

#5. (Page 64) DO NOT shade any mid-tones too dark (#6-#10, page 66) for this phase of your work.

8. You can place an extra piece of paper under your drawing hand to eliminate smudging and soft blending of tones from your hand moving across already shaded areas. See page 68 for illustration.

9. Complete the shaded work adding slightly darker and slightly darker tones to the last value, which will be your darkest tone (#10). Save the dark values for last.

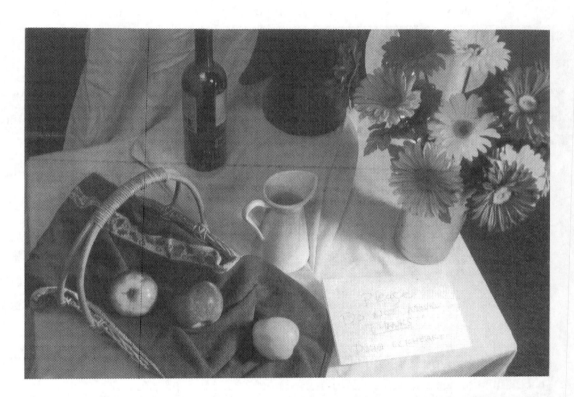

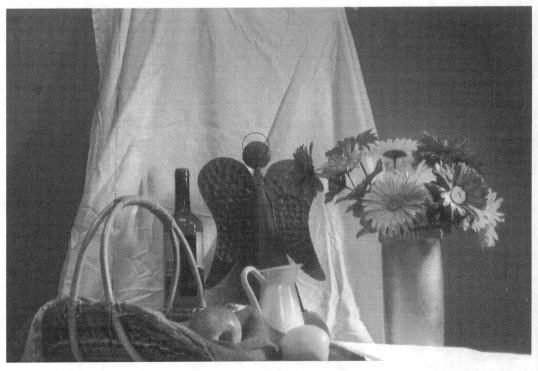

Preliminary drawing/study for full value drawing
The circles are a measuring device using the circle on head of angel.

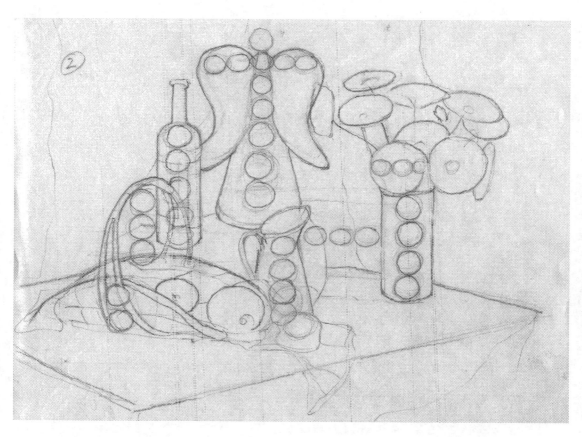

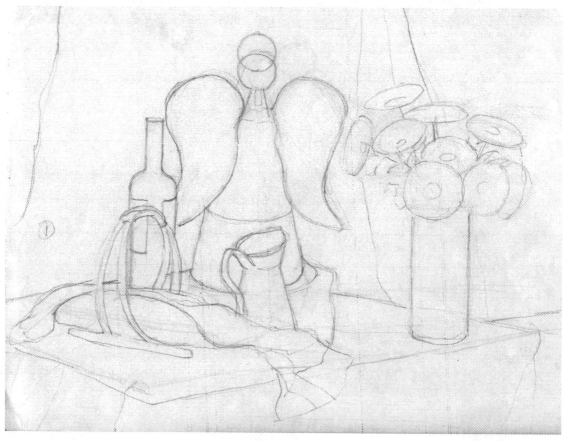

Shading exercise with 1 to 7 tones
Remember from the value scale 1 is the lightest and 10 is the darkest

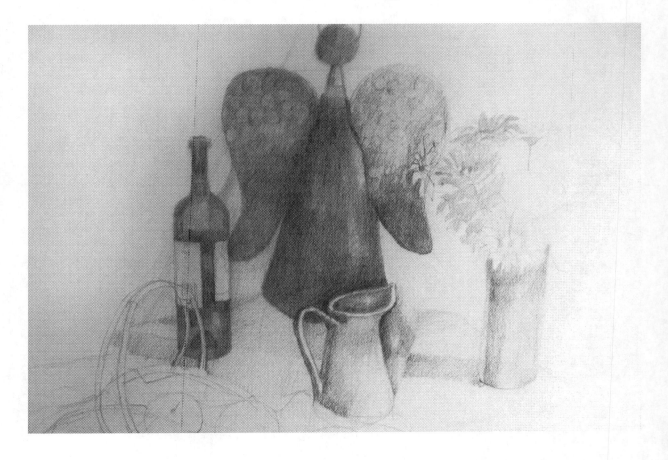

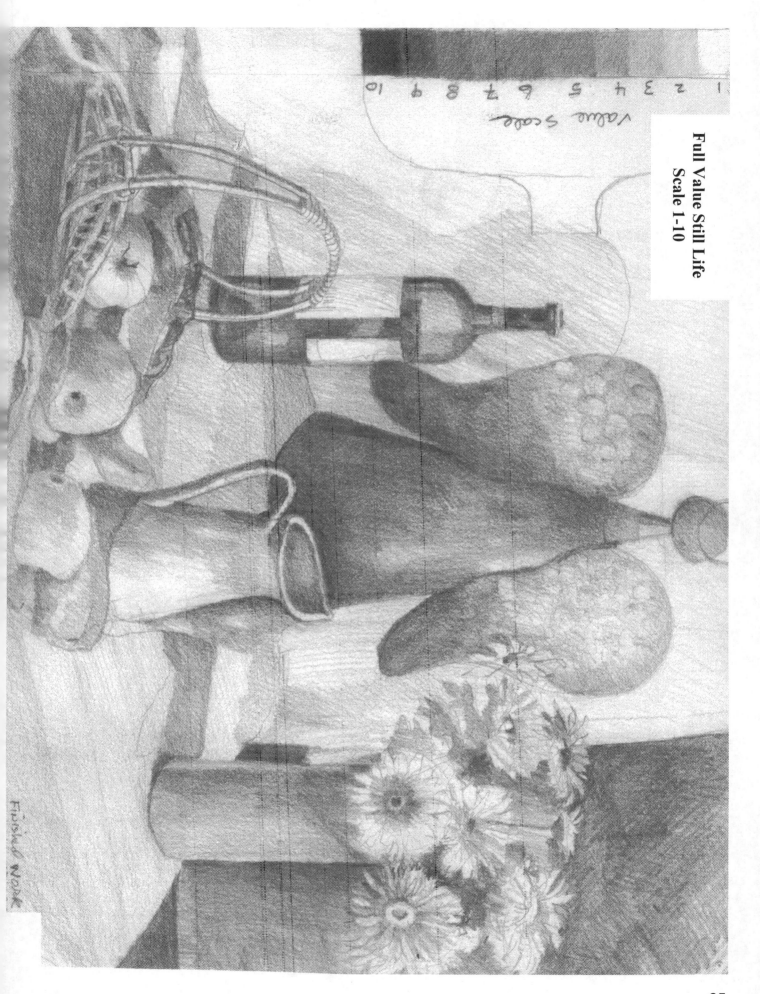

Full Value Still Life
Scale 1-10

Full Value Scale 1-10
Farm Landscape

Follow these instructions
Please read first---then draw.

1. Enclosed in the next group of subject matter is a photo and basic drawing by me of that photograph. Photo page 67. Take a quick look.

2. Please study that photo and drawing and on page 67 to 73 produce your own drawing of this farm subject matter with a sketch copying my farm landscape drawing!!

3. Then find your own photo or actual place from which to sketch and make a drawing of this subject matter (farm landscape) of your own. Use the practice pages 59 & 60. (Better paper)

4. Be sure to see how many of the basic shapes you can find in this scene. See page 70. Begin with light line drawing or sketch of the farm scene.

 - Notice the entire farm is below eye level. Eye level is along & horizontal to the horizon line where earth meets sky in the distance.

5. Values 1(light) to 5 (mid-tone) on value scale is worked in first (See illustration on pages 68 & 69) No surface under drawing other than smooth hard surface like Masonite.

 - Place a small piece of paper under your drawing hand to prevent smearing of pencil tones. See illustration on page 68. Use the photo for reference- but allow or give yourself permission to vary when necessary.

 - Organize and plan ahead- where are the darkest darks, 6-10 on the value scale. They should be placed and pushed last in your work.

6. Values 6-10- darkest darks placed in order to facilitate a solid composition and integrated work. Continue to rotate pencils and sharpening so you are always working with a sharp point. See illustration on pages 68, 69, & 70. Then final work on page 72.

Remember, you are an artist---not a camera---you can change, re-arrange, simplify, edit, push-pull-emphasize, de-emphasize. You are translating, transforming, this space into your own personal artwork.

Actual picture of farm

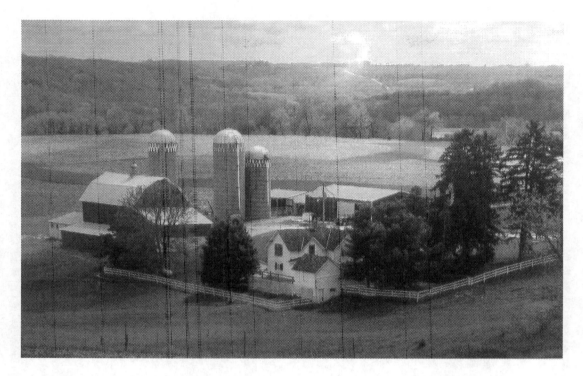

Sketch of farm

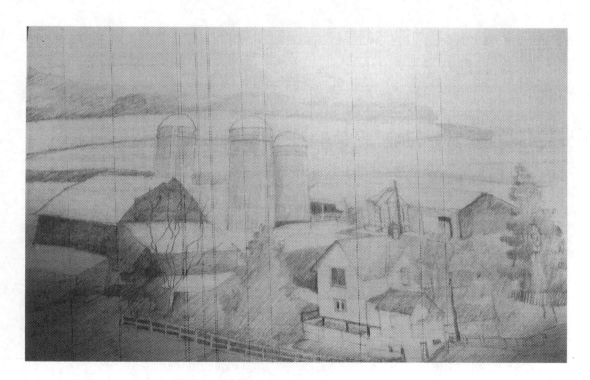

Sketch of farm

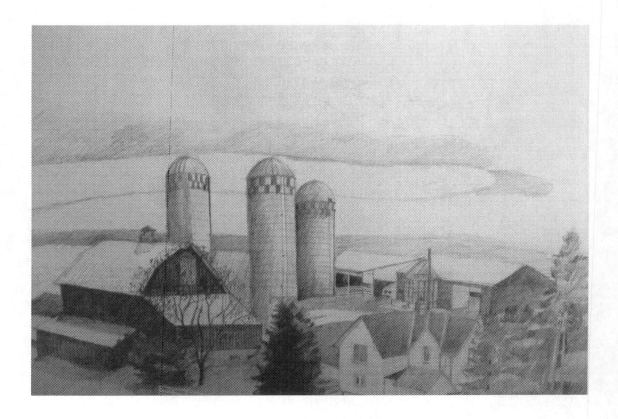

Artist picture of drawing the farm scene

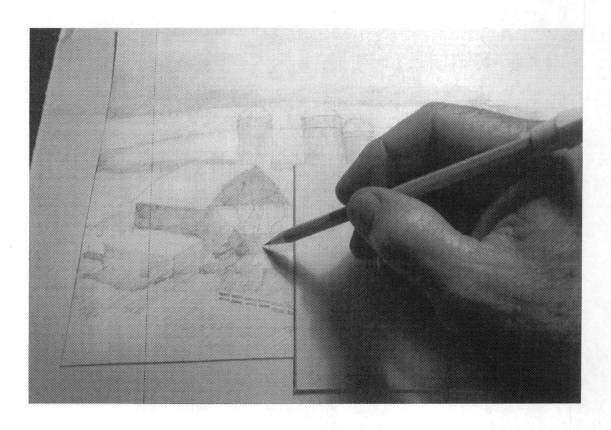

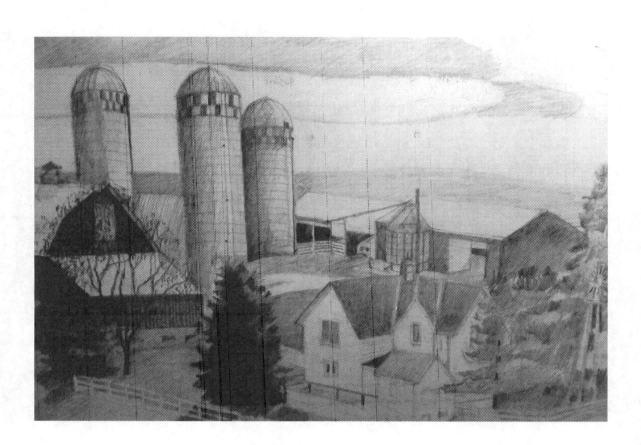

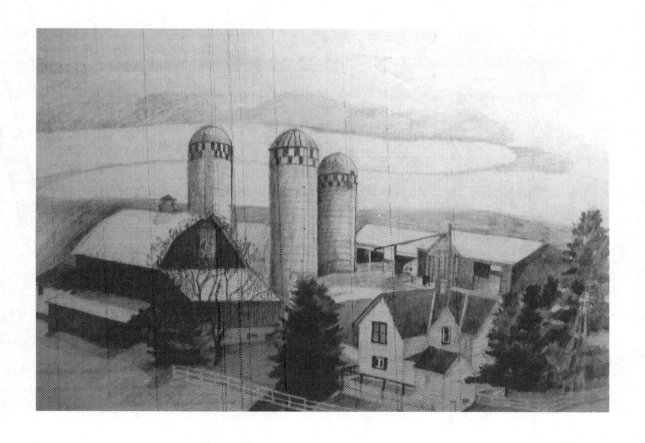

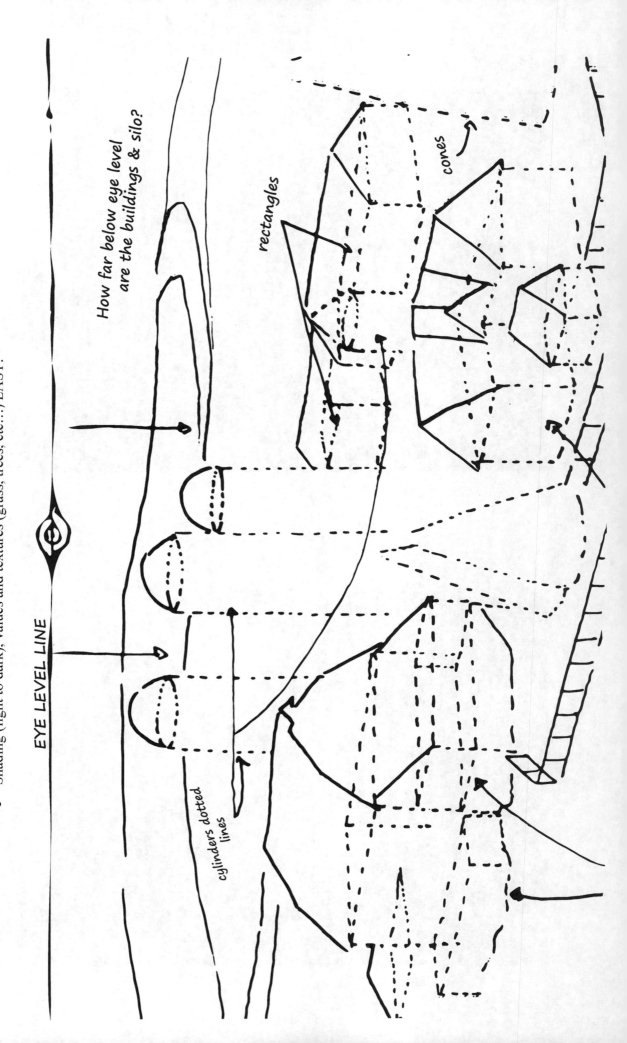

*NOTE

- See the basic shapes first (rectangle, cylinder, cone, etc...)
- Big shapes to small shapes & detail and light lines.
- Shading (light to dark), values and textures (grass, trees, etc...) LAST!

EYE LEVEL LINE

How far below eye level are the buildings & silo?

rectangles

cones

cylinders dotted lines

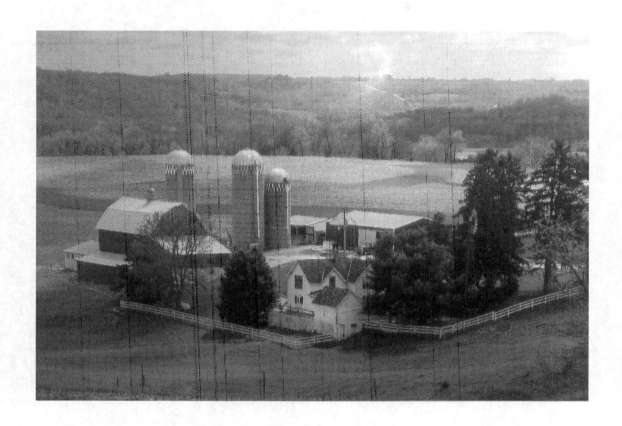

Look carefully at this final pencil rendering of the farm scene.

Look from the photo to the drawing and back—photo and back.

Look at specific areas and how I have changed and re-arranged certain elements such as:

- Lowering the tree line on the right to expose more of the background buildings and rooflines.

- Opening rather than closing the doorway on far right background shed.

- Emphasis on the vertical and horizontal siding on the barn and house.

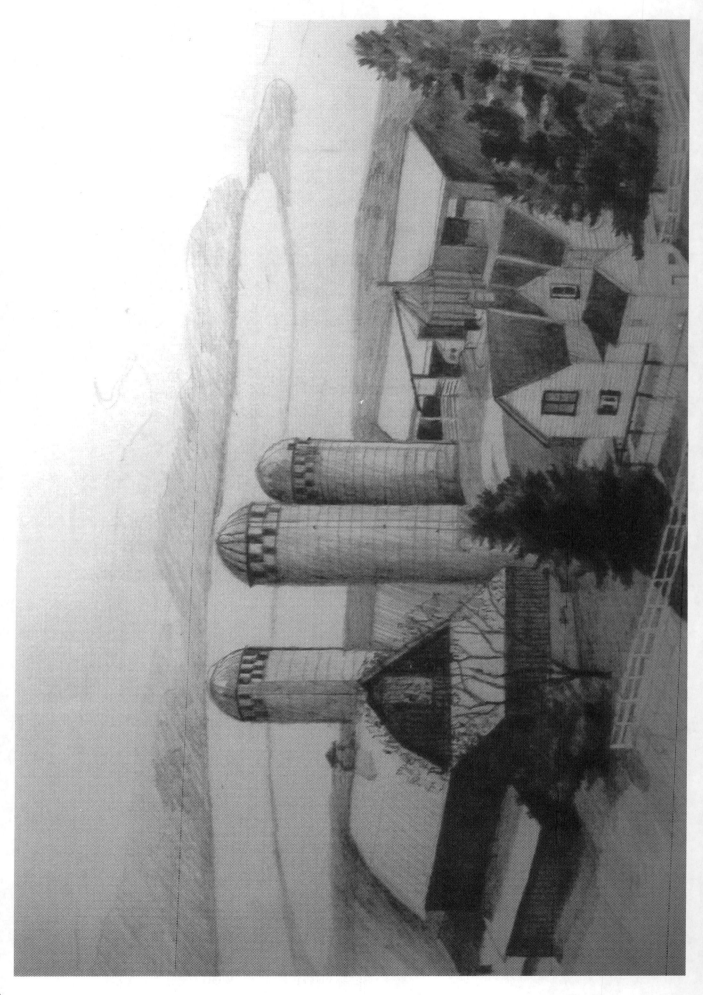

Practice Page

Your drawing

Farm/Landscape

Try a drawing of your own landscape

Conclusion

Welcome to the end of this "Eye Training" beginning drawing workbook. But remember, the end is now really **only the beginning**!!! Now begins the real effort! The really hard work!! You have done very well to follow the rigor and the discipline it took you to establish a secure foundation in your visual training. These are the basics. Once firmly and solidly built with more and more drawing & sketching you will continue, with more practice to develop your own personal mark making, shading, and value signature, and unique style that is your thumbprint.

As you continue to develop as an artist your world will expand and perhaps your art medium will move into painting, printmaking, design, sculpture, etc. However, this basic level of eye training will support all your future endeavors in the visual arts. At the very least, as I said at the beginning of this booklet- a new awareness-change therapy, a new YOU.

Surround yourself with what you love, for you will become at one with them.

Douglas Eckheart's work and life are intricately woven together through a long term residency of 40+ years in northeast Iowa, a region of little known, yet uncommon natural beauty. His artwork expresses a love and deep appreciation for the subtle moods and mysteries found in nature as revealed through the ever-changing seasons. Although representational, Doug's work should not be considered a naturalistic copy of photographic realism. Color, shape, texture, and light are transformed and modified to portray nature as a life force. Doug compares this process of personification of the spirit in the land and its Creator to poetry or music. In describing his work as tone poems, he uses a visual metaphor to communicate and translate the expression of moods, experience, and feeling. Doug is a productive, active artist, as well as professor emeriti at Luther College. He has presented over 75 one-person exhibits and 40 group shows in New York City, Chicago, Des Moines, in addition to Malta and Norway.

He has served as an artist-in-residence, keynote speaker, juror for regional and national competitions, department head, gallery director, and curator. He has been featured in *American Artist* magazine and the Iowa Public Television's series, *Living in Iowa*. Doug received his BA at Concordia College in Minnesota and his MFA degree from Bowling Green University in Ohio.

In 2009, Doug retired from <u>full</u> time teaching. He has since opened an art gallery/studio/workshop space in downtown Decorah, Iowa. Doug continues to create his signature artwork in studio. He also teaches workshops in drawing and painting in his gallery. He has taught workshops in many Midwest locations, in Norway, and on the island of Malta. Most recently he taught a successful workshop in San Clemente, California.

For more information check out his website at www.eckheart.com